Margaret Hooks

MODOTTI TINA 55

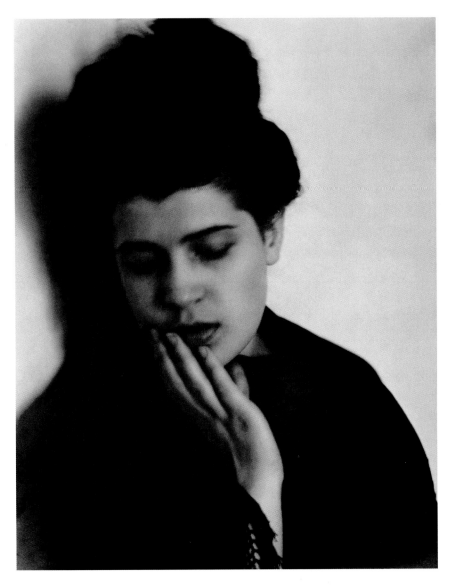

Despite her brief career in photography, Tina Modotti is now considered one of its pre-eminent twentieth-century proponents. In a seven-year period she achieved a standard that other artists took a lifetime to reach, and recognition of the importance of her work in this field is evidenced by an ever-growing interest in the life and output of this remarkable woman and pioneer of modern photography. This is a relatively new development, however, since it is only in recent years that Modotti's reputation has been rescued from the myriad of myths in which it was mired for decades. From an early age, Modotti was exposed to the most radical ideas of the first half of the twentieth century and she opted to ride the crest of the transformations these inspired. Though she was born more than a century ago, her story is essentially modern – rooted in being poor, female and foreign in America. Ultimately, it is a tale of survival, of ambition and achievement, creativity and commitment; of a life lived on the cutting edge with courage and flair.

Modotti's trajectory thrust her into the midst of some of the century's most dramatic experiences of social upheaval – post-revolutionary Mexico, Berlin during the rise of Fascism, early Stalinist Russia and Spain during the Civil War. She showed enormous personal courage, not only in life-threatening situations but also in her defiance of tradition, particularly in her emotional and career decisions. She chose sexual independence over marriage, political commitment in place of personal security and eventually revolution above art. This is not to say that she was always steadfast in what she undertook; in truth she was a kaleidoscope of contradictions, frequently ambivalent and surprisingly naïve.

In 1923, Modotti moved from California to Mexico, where she studied photography with the renowned American photographer Edward Weston. Together they

introduced modernist photographic practice to Mexican artists, and these artists, particularly the muralist painters such as José Clemente Orozco and Diego Rivera, in turn influenced their work. Using her camera to capture life in Mexico during some of its most tumultuous and vibrant post-revolutionary years, Modotti achieved the marriage of a modernist photographic aesthetic with Mexican revolutionary culture.

Yet she was never truly at ease in her role as an artist. She frequently emphasized the difficulty she experienced in reconciling her life and her art. In a letter to Weston in 1925 she wrote: '*Art* cannot exist without *life*, I admit, but ... in my case life is always struggling to predominate and art naturally suffers.' For Modotti the conflict was specifically between art and politics. Although she retained her interest in photography and her friends in the artistic milieu, ultimately it was politics that defined how she lived her life. She agonized over what she saw as the conflict between the purity of inspired creation and the exigencies of a world fraught by social injustice. And as the daughter of an Italian socialist she had been familiar with these injustices from an early age. Unable to find work in Italy, probably as a result of his radical politics, her father had to abandon the family in Udine and migrate to the United States. Giuseppe Modotti's departure, and subsequently that of her older sister, Mercedes, left Tina the family's sole wage earner at just twelve or thirteen years old. Combatting a crippling poverty that left a lasting mark, she worked tedious, soul-destroying hours in a local silk factory.

Eventually, Giuseppe sent for his children to join him in America. Tina's turn came in 1913 when she was sixteen years old. She boarded one of the many emigrant ships leaving Genoa for America, wearing what she later described

as a 'silly hat' covered with artificial flowers and cherries that she had made herself. She was headed for San Francisco where her father and elder sister now lived. Once there, she immediately started work, joining her sister Mercedes in the sewing room of the I. Magnin department store. Her vitality and beauty, however, soon attracted attention and she was offered work as a store model, displaying the latest fashions to prospective clients.

Two years after her arrival, San Francisco was host to the Pan-Pacific Exposition, an event that brought intense cultural life to the 'city by the bay'. Modotti spent many hours in the exhibition halls, where she was exposed for the first time to the latest in modern art and photography movements. Within two years of this exposure she had made the transition from modelling to the stage and had become a popular actress in the thriving local theatre of Little Italy. She had also met and fallen in love with a young bohemian painter and poet, Roubaix de l'Abrie Richey, known to everyone as Robo. In 1918, in search of fame and fortune, the young couple headed for Los Angeles and Hollywood. Robo initially found work in the cloakroom of a local cabaret and Modotti was cast in minor roles in silent films. Although she was only in her early twenties, film critics even then referred to her 'magnificence and nobility', traits that were to become the hallmarks of her beauty. But Hollywood directors were looking for *femmes fatales*, heroines and *ingénues*. They could not envision an Italian woman as anything other than a vamp, and Modotti became typecast as such, even in her leading roles.

Los Angeles, however, was not limited to Hollywood for Modotti and Robo. Robo was also an accomplished batik artist, and he and Tina soon became part of a bohemian circle of poets, pundits, artists and anarchists, fascinated by

everything from Eastern mysticism to free love. They also followed closely the ongoing Mexican Revolution and renaissance in Mexican art. It was through this group that Tina and Robo met and befriended the photographer Edward Weston. Already an established photographer, Weston was then married with four young sons, but that did not curb his taste for a bohemian lifestyle and clandestine romances. There was an instant, electric attraction between Modotti and this short, wiry man with the warm brown eyes and a palpable virility. He and Tina fell in love, and thus began a relationship that led to one of the most exciting partnerships in photography of the twentieth century.

In 1921, partly in response to Modotti's affair with Weston, Robo left for Mexico on an artist's adventure with plans to arrange an exhibition of his batiks, along with the photographs of Weston and other Californian photographers. However, just a few months after his arrival, he contracted smallpox. Modotti was already in Texas en route to visit him when she heard the news and rushed to Mexico City to be at his side. She was with him for a few days before he died, and stayed on to arrange his burial and finalize plans for the exhibition of his and Weston's work. While there she met Diego Rivera and many of the other local artists and writers that Robo had befriended during his stay. But Modotti had to leave Mexico suddenly when her father became seriously ill. He died a few weeks after she arrived back in California, leaving her feeling devastated by her double loss.

Her relationship with Weston was blossoming, however, and with it a new self-awareness. She was suddenly no longer willing to play the parts she was being offered in Hollywood, nor was she at ease with her new role as model for the cameras of Edward Weston and his photographer friends. She was helping run Weston's studio and doing some darkroom work when she decided she wanted

to be a photographer in her own right and have her own studio. There was a tradition of photography in the Modotti family: Modotti's uncle, Pietro Modotti, was an innovative and respected photographer and she had been a frequent visitor to his Udine studio as a child. Her father had also attempted to establish himself as a photographer and had opened a studio in his early years in San Francisco, but the business was not a success.

Modotti and Weston talked about leaving California; they found their lives there too restrictive. Weston in particular was anxious to be rid of the middle-class mores in which he felt his family life was mired, and Mexico seemed an attractive choice. So, boarding the SS *Colima* from the port of San Pedro in July 1923, Modotti headed for Mexico once again, this time with Weston, his son Chandler, and an agreement that, in exchange for helping him run his studio, Weston would teach her photography. Weston did not speak Spanish, but Modotti did, and as a result she had already made many invaluable contacts within Mexico's artistic colony. Also included in their 'contract' was the agreement that each would have complete sexual freedom. Weston had insisted on this and Modotti had acquiesced; it was a demand he would come to regret.

Their home in a fashionable neighbourhood of Mexico City quickly became a meeting place for leading artists and intellectuals, then enjoying a heyday with the encouragement of education minister José Vasconcelos, the driving force behind the cultural renaissance sweeping the country. They continued their bohemian lifestyle; Modotti smoked a pipe and was reputedly the first woman to wear blue jeans in Mexico. The raucous parties they frequently organized attracted revolutionaries, aristocrats and penniless artists. It was at one of these parties that Diego Rivera first wooed Frida Kahlo. Those closest to Modotti at the time were

Mexican painters and muralists such as Lola Cueto and Diego Rivera. She also cultivated friendship with foreign artists and writers then living in Mexico, such as D.H. Lawrence, Jean Charlot, Anita Brenner, René D'Harnoncourt and Frances Toor, who was then editing the magazine on Mexican folklore *Mexican Folkways*, also the main vehicle for the work of expatriate artists. But Modotti and Weston also worked hard and took their photography very seriously.

During this period, under Weston's tuition, Modotti became an accomplished photographer in her own right. Moving to her new place behind the camera, she made the transition from object in the art of others to subject, creating her own art. Although Weston clearly influenced her work, her photography took a direction of its own from the start. Essentially, she photographed the Mexico she loved — Indian women and their plump babies, peasants marching in enormous straw hats, murals, painters and poets, stately palms, sugar cane and the icons of the Mexican Revolution: the ear of corn, the bandolier and the guitar. Her fascination with form is equally reflected in her exhilarating still lifes, such as *Mella's Typewriter* (page 81), *Glasses* (page 27) and *Roses* (page 31).

In 1924, Weston had an exhibition in which some of Modotti's first photographs were shown. While these were well received, it was Weston's nude studies of her that attracted most attention and scandalized the Mexican upper classes, many of whom were Weston's studio clients. Unlike Weston, Modotti liked to experiment in her work and was capable of challenging his purist maxims. She explored the potentiality of multiple exposure and photomontage, and cropped and enlarged many of her images. It is a cropped image that best illustrates her first attempt to resolve the two major themes in her life — art and politics. *Workers' Parade* (page 45), taken from the rooftop abode of painter Paul

O'Higgins on May Day 1926, is a detail of a column of *ejidatarios* (communal subsistence farmers), symbolic of rural Mexico and agrarian reform, marching in their large straw hats. But it is the aestheticism of the enlarged detail, reflected in the sunburst-like patterns of light on the sombreros, that stays with us, rather than the political content of the image as it was first conceived. This photograph, and the original documentary image with its strong social-justice message, mark a point of departure in Modotti's work. Both images reflect her ambivalence with respect to the direction her photography should take, and are the first photographs that illustrate the melding of the formalism and aestheticism of her earlier work with her growing interest and involvement in Mexican revolutionary politics.

Modotti's work embraced several disparate areas. Firstly, she was documenting Mexican folk art for publications such as *Mexican Folkways* and *Idols Behind Altars*. She was also recording the work of the leading Mexican artists of the day, which included not only her better-known images of the art of muralists such as Orozco and Rivera, but also that of the painters linked to the *Contemporáneos* group, Julio Castellanos and Rufino Tamayo. She carried out photo assignments for *El Machete* newspaper, which include some of her most poignant studies of the disparities in Mexican society, as well as her only attempt at reportage. Then there was her studio work – professional portraits of Mexico's rich and famous, such as Dolores Del Rio (page 37) and Antonieta Rivas Mercado (page 115), poets and painters like Lola Cueto (page 71) and Baltasar Dromundo (page 107). Even in this, her 'bread-and-butter' work, Modotti's approach was often unconventional for the time in its use of low-angle viewpoints. And finally, there are the photographs she made for pure pleasure – work-worn hands holding a shovel, and the slender forms of cool lilies.

Through her close working relationship with Rivera (she also posed for several of his murals and had a brief affair with him), Modotti became influenced by his political ideas. He was then a leading Communist, as were many of the artists she knew. But probably the greatest influence at the time was the broodingly handsome muralist of Indian descent, Xavier Guerrero. They began a relationship in 1925 that lasted for two years. A dedicated Communist, Guerrero greatly influenced Modotti's perception of the role of photography in the struggle to bring about social change. 'You opened my eyes,' she wrote to him several years later, and certainly the social content of her photographs increased as their association deepened.

Meanwhile her partnership with Edward Weston was floundering. Both had followed the sexual freedom mandate and had their share of affairs. Weston had more difficulty accepting hers than vice versa. In addition, Modotti's deepening social conscience had driven them further apart, causing her to put their relationship on a platonic basis. In 1926 Weston left Mexico, just as Modotti turned thirty. She had become more politically active and was involved in many of the struggles against the social injustices of the time. By 1927 she had joined the Mexican Communist Party and was taking photographs for the official newspaper, *El Machete*. Her growing fascination with Communism is reflected in her iconic studies of the bandolier, the hammer and the sickle, and of peasants reading *El Machete* (page 91), all made at around this time. After Weston's departure, she had moved into the legendary Zamora building – the ten-storey haunt of bohemians and radicals, dubbed the 'Tower of Pisa' because of its alarming tilt. Her home became a meeting place for Latin American political exiles (among them Augusto César Sandino, the legendary Nicaraguan rebel leader) and Modotti became involved in support of their liberation struggles.

It was also a haven for some of Mexico's leading artists: Rufino Tamayo went there to sing and play his guitar, and Frida Kahlo, David Alfaro Siqueiros and photographers Lola and Manuel Alvarez Bravo were also frequent visitors.

Modotti had an important influence on the young Kahlo and was responsible for her joining a Communist youth organization. According to Alejandro Gomez Arias, then a close friend of Kahlo, Modotti also encouraged her to dress more soberly, and for a short while Kahlo wore a simple skirt and blouse – a style that was Modotti's hallmark when the fashion among her friends was for exotic indigenous clothing. She also gave Kahlo the hammer-and-sickle brooch that she wears in Rivera's mural *The Arsenal*, in which Modotti and Kahlo are depicted handing out arms to the people. In this ambience, Modotti met and fell in love with the young Cuban revolutionary leader Julio Antonio Mella, of whom she made some her most striking portraits. In January 1929, just a few months after they began living together, he was assassinated as they walked home arm in arm along a downtown Mexico City street. That year was a crucial one for Modotti. In a surprising turn of events, she was accused of having arranged Mella's assassination and of being a Fascist spy, and was subsequently placed under virtual house arrest. The inquest on Mella's murder turned into an 'inquisition' on Modotti's morality, and she was pilloried in the local press for her unorthodox views on marriage and sexuality, and for having posed nude for Weston. But local women's groups and trades unions rallied to her support, and the leading artists of the day wrote to newspapers explaining that Weston's photographs were artistic rather than pornographic.

Further scandal erupted in December of the same year when Modotti's first one-woman show, organized by Baltasar Dromundo, opened at the National

University. Modotti had set a serious intellectual tone for the exhibition with her published statement *On Photography*. Echoing the position of the Mexican muralists, she refers to the camera as a 'tool' and writes: 'I consider myself a photographer, nothing more. If my photographs differ from that which is usually done in this field, it is precisely because I try to produce not art but honest photographs.' Weston's influence is still reflected in her disdain for the 'majority of photographers [who] still seek "artistic" effects, imitating other mediums of graphic expression', or for those 'who continue to look myopically at the twentieth century with eighteenth-century eyes.' But it is the final paragraph that highlights the political undercurrent in her photography and the extent to which her political idealism had moved her photography beyond formalist concerns: 'Photography, precisely because it can only be produced in the present and because it is based on what exists objectively before the camera, takes its place as the most satisfactory medium for registering objective life in all its aspects, and from this comes its documental value. If to this is added sensibility and understanding and, above all, a clear orientation as to the place it should have in the field of historical development, I believe that the result is something worthy of a place in social production, to which we should all contribute.' The exhibition was billed as the 'First Revolutionary Photography Exhibit' and inaugurated by Siqueiros, who was arrested a few days later for conspiring against the government. In the ensuing publicity, Modotti's liberal lifestyle was once again dragged into the Mexican press.

Two series of photographs made by Modotti earlier the same year, 1929, clearly reflect her new position. First is a group of images made in the isthmus of Tehuantepec, an area renowned for its matrilineal heritage and the proud, handsome women who still control most of its commerce. Though not technically

striking, these images are appealing in their simple, unmanipulated quality – documenting the daily life, customs and costume of a community. The second is a series of photographs made for *El Machete* to document a May Day march organized in protest against arrests of Communist Party members. It is so far the only known sequence of Modotti's reportage or action photography. These images are interesting in light of the debate over Tina Modotti's decision in 1931 to abandon photography for full-time political activism, and they contradict her stated reasons for doing so: that after years of making carefully composed images she was uncomfortable and unfamiliar with street photography. The photographs show her at ease in this environment, moving quickly in full view of her subjects to best record the events as they occur.

In 1930, there was an attempt on the life of President Ortiz Rubio, followed by a crackdown on government opponents. Many writers and artists were imprisoned, including Modotti, who was erroneously accused of having been involved in the plot. After thirteen days she was released, given two days to leave Mexico, and put on a freighter bound for Europe. On board the ship, Modotti deepened her friendship with the Italian Communist agent Vittorio Vidali, whom she had met in Mexico in 1927. He encouraged her to go to Moscow with him, but she chose to stay in Berlin. While there she came into contact with other artists who were changing the face of European culture. She met many of the Bauhaus school of photographers and designers, and had a show of her work at the studio of Lotte Jacobi, but felt unable to take many photographs. She attributed this to a number of factors, among them the light, her camera and the new style of photographing. After a few months she left Berlin to join Vidali in Moscow. Soon after her arrival she met Sergei Eisenstein – whose film *Que Viva Mexico!* (1932) is said to have been influenced by her photographs – and started

planning an exhibition of her work. Her friendship with Vidali became more intimate and they began living together. Both were working for International Red Aid, a Communist front organization that aided political prisoners and their families worldwide, and Modotti's tasks included dangerous missions smuggling funds into western Europe for persecuted Communists. She and Vidali were in Spain for the outbreak of the Civil War. He became famous as 'Comandante Carlos', and she played a key role in directing international aid to the Republican cause. Later, she worked for *Ayuda*, the weekly organ of International Red Aid, following the scenes of the major battles throughout Spain

The Spanish Civil War and other events in Europe absorbed Modotti's energy and she sacrificed her art to what she believed was a greater cause. In Spain she was oblivious to the suggestion of colleagues and friends, such as Robert Capa and David Seymour, that she should begin taking photographs again. It is understandable that her Italian socialist roots would lead her to devote herself to promoting Communism and combating Fascism, especially in the strife-torn Europe of the 1930s. It is less understandable why, during those years and until her death in 1942, she felt that her photography could not be of service to these imperatives nor integrated into her political activity as it had been during her time in Mexico.

Perhaps the key lies in the Soviet Union of 1931. Modotti's Mexican friend, the singer and composer of revolutionary *corridos* Concha Michel, recalled visiting Modotti in Moscow that year and found her despondent about her photography because 'they' did not appreciate her work. There was no doubt in Michel's mind that 'they' meant the Stalinists. Not only did Modotti's photography fail to fit in with Stalinist concepts of revolutionary art, but as a Soviet Communist Party

member working with International Red Aid — and along with Vidali, one of its leading officials — Modotti would have had to produce only 'revolutionary' art, or face the consequences. She was too much of an artist to see her photography reduced to mere propaganda and at the same time too devoted to the Party to risk disapproval or expulsion.

Following Franco's victory in 1939, Modotti returned to Mexico where she and Vidali lived incognito in virtual poverty. She avoided the artists she had known in the 1920s and refused to take up the camera again, though she did work with a photographic expedition for a book on Mexico in 1940. It was probably not until just a short time before her death in 1942 that she began to doubt her decision, looked up old friends such as Orozco and Alvarez Bravo, and attempted to acquire a camera to start photographing again.

In hindsight we can see that Modotti renounced photography for a political ideal that turned ugly. Blinded by the goal of a socialist utopia she allowed herself to become involved in unsavoury Stalinist tasks that implicated her in crimes against those she had once admired, and when she realized her error it was too late. Yet such a step was motivated precisely by the ideals that, combined with her artistic prowess, produced some of her best work. She died suddenly in January 1942, in a taxi taking her from a dinner party given by the Bauhaus architect Hannes Meyer. Even in death, scandal was to follow her. The Mexican press claimed she had been poisoned by the Stalinists because she 'knew too much'. Her funeral itself became a political event. Accompanied by leading left-wing Latin American and European writers and artists, she was buried under enormous bouquets of lilies and roses, the flowers she had rendered so exquisitely with her lens.

Church Interior, Tepotzotlan, 1924. This photograph was taken on a romantic weekend spent in a candle-lit seventeenth-century monastery in the town of Tepotzotlan about two hours from Mexico City. Modotti made this photographic trip with a group of friends, among them Edward Weston, who refers to the photograph in his *Daybooks*: 'Tina printed her most interesting abstraction done in the tower of Tepotzotlan. She is very happy over it and well she may be. I, myself, would be pleased to have done it. She printed from the enlarged positive, so she has a negative print and shows it upside down. All of which may sound "fakey" … but it really is very genuine.'

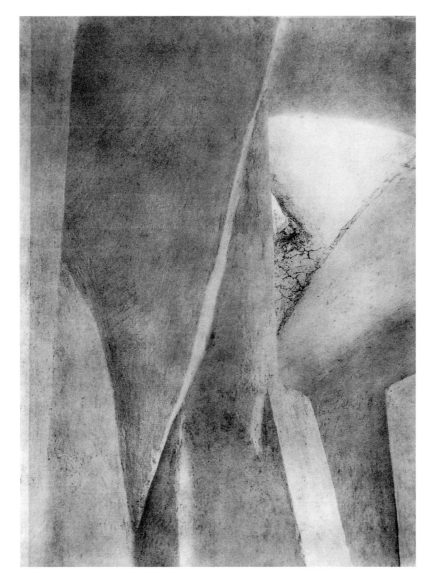

Circus Tent, Mexico City, 1924. This early picture was made when Modotti an Weston went to the Russian circus in Mexico City to take photographs. Bot loved and photographed the great sweeping folds of the circus tent and th abstract patterns of the rows of seating. But Modotti also realized that circuse are all about people and included a human figure in her composition, unlik Weston whose resulting prints were pure abstractions.

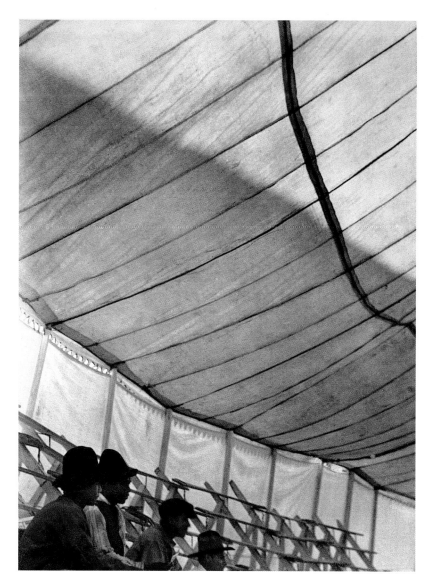

Edward Weston, 1924. It is interesting that Modotti so seldom photographed her teacher and lover Weston. In fact, the portraits from this sitting are the only ones that can be definitively attributed to her. He, on the other hand, made many of her, which form a testimony to the strong emotional bond between them. This portrait and the others from the sitting, however, reveal nothing of that bond. It almost seems as if they were made to publicize Weston the photographer, or to advertize his studio. With its emphasis on his camera and his respectability, this stiff, rather pompous-looking portrait has little to do with the sensitive, sensual, bohemian artist that was the real Weston.

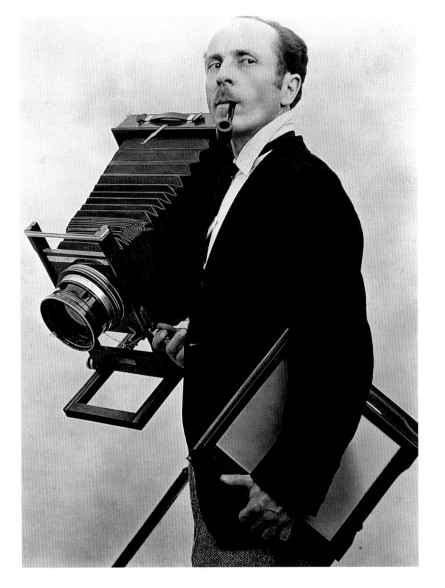

View of Rooftops, Mexico City, c.1924. Broad geometrical lines zigzag across the frame of this modernist image. Made from the rooftop of Modotti's and Weston's home on Calle Lucerne, a wealthy neighbourhood of Mexico City, this is a stunning study in form. Modotti loved Mexico's *azoteas* – rooftop terraces of multiple uses – where she sunbathed naked, played tag with Weston and his son Chandler and posed for many of the splendid nude photographs Weston made of her.

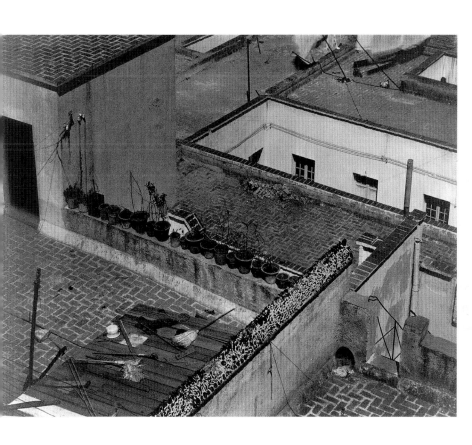

Telephone Wires, 1925. This photograph of telephone wires was made when Modotti was involved in one of the projects of a group of Mexican artists called the *Estridentistas* (The Strident Ones). This vocal group incorporated elements of Dadaism and Futurism into their innate brand of bizarre performance art and protest. The picture was published in the leading Mexican contemporary art magazine *Forma* in 1927, together with *Tank No. 1* (page 57) and *Construction Worker on Girders* (page 59). These were photographs that Modotti made for publication in a book of *Estridentista* poetry by the German writer List Arzubide. The *Estridentistas* were enamoured with new technology, particularly means of communication such as the radio and telephone. *Telephone Wires* was also published in the prestigious Parisian publication *transition* in 1929, alongside the work of Man Ray and other leading artists of the day.

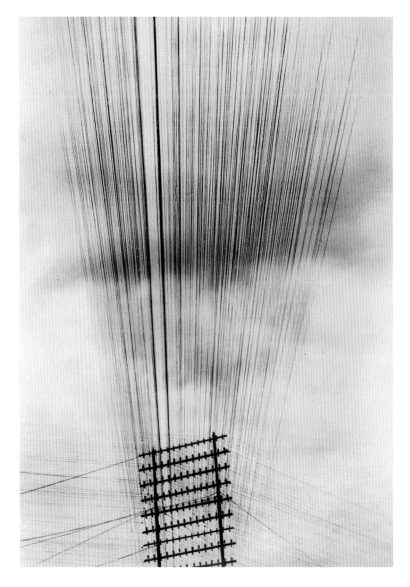

Glasses, 1925. *Glasses* is another early example of Modotti's experimental photographs. The swirling rims of the wineglasses used in this multiple exposure create a luminous field of harmonious circles that fill the whole of the frame. This photograph, along with most of Modotti's work, influenced a generation of Mexican photographers, among them Manuel Alvarez Bravo and Agustin Jimenez, whose mathematical arrangement of glass tumblers over a tray done in the 1930s owes much to this image.

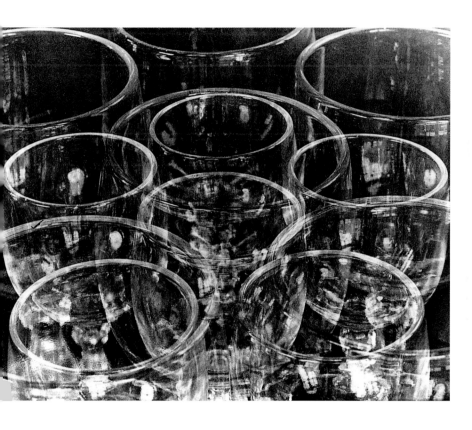

Sugar Cane, 1925. Stalks of sugar cane crowd the frame and bleed off the edges of this abstraction. The influence of Weston's formalism and an emphasis on the 'thing itself' are evident in this photograph, but Modotti's use of the tropical sugar cane as her subject imbues the image with the spirit of place that permeates much of her work.

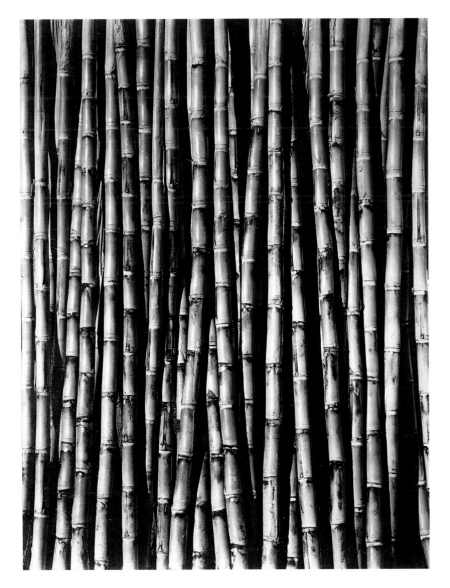

Roses, 1925. The roses in this image were a gift to Modotti from Weston and th picture exudes the sensuality that permeated their relationship at that time. Th frame is filled with the lush, languid rose petals, as if inviting us to bury ou faces in them and breathe deeply their heavy scent. The composition is almos square, and the tonal range a featureless black and white. The image has glowing, almost decadent quality that pulls us into the swirling forms of th petals and entices us to lose ourselves in their beauty.

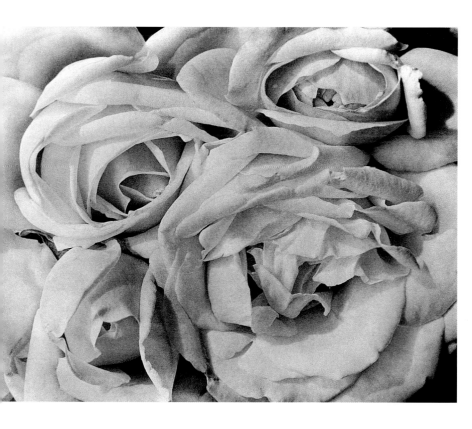

Calla Lilies, 1925. This is another of Modotti's sensual flower photographs, but in contrast to *Roses* (page 31) this is a cool, elegant image. It has strong graphic elements; the two flower stems traverse the image from top to bottom, drawing the eye of the viewer from the bottom of the picture to the top, focusing our attention on the milky-white heads of the flowers. This is a study in contrasts of both tone and form. The fragility of the petals is exquisitely offset by the strength of the stems.

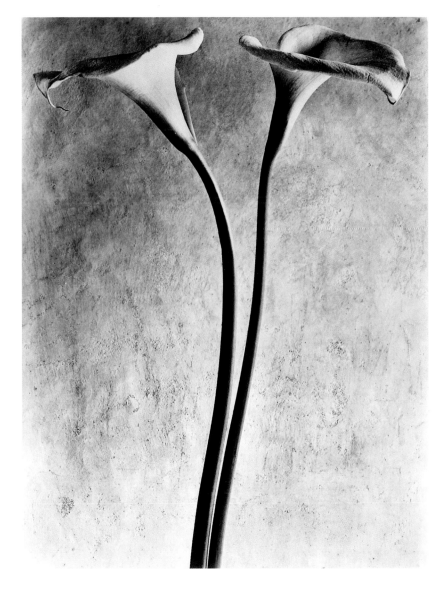

Nopal Cactus, 1925. The paddles of the nopal cactus have been photographed at such an angle that they have become almost unrecognizable as the iconic plant of the Aztecs, renowned for its medicinal properties and still an integral part of modern Mexican cuisine. The photographer's interest here is not in the properties of the plant, but its planes – the smooth, curved discs that fill the centre of the frame – and the desire to produce a strong, abstract image.

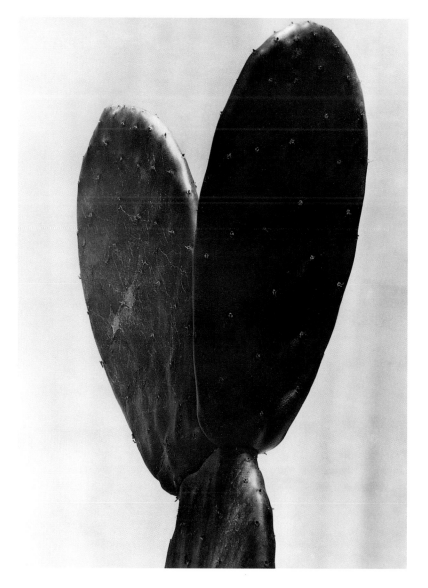

Dolores Del Rio, 1925. During 1925, Modotti was moving from managing Weston's studio to developing her own clientele. One of her first clients was Mexican actress Dolores Del Rio. Del Rio was embarking on a successful Hollywood career and wanted portraits that she could use to promote it. Modotti's image is no straightforward publicity shot, however. The striking composition and the sitter's off-camera gaze are examples of the unconventional elements that informed Modotti's portraiture from its beginnings.

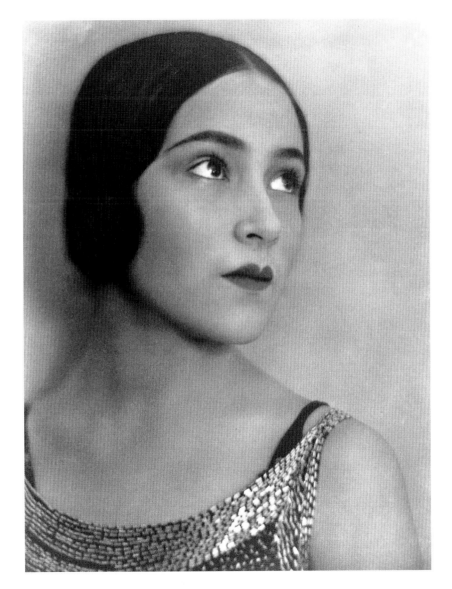

Lily and Bud, c.1925. This simply beautiful image of a lily and bud is a fine example of the maxim popular with Modotti and many of her contemporaries that the aim of photography was to portray the 'thing itself'. Here, Modotti is totally focused on the lily and on conveying the qualities normally associated with this flower – beauty, purity and simplicity. The composition and lighting are perfect in this highly aestheticized image and, in contrast to *Calla Lilies* (page 33), it is the luminosity of the flower, rather than the stalks, that draws our gaze upwards and into the image.

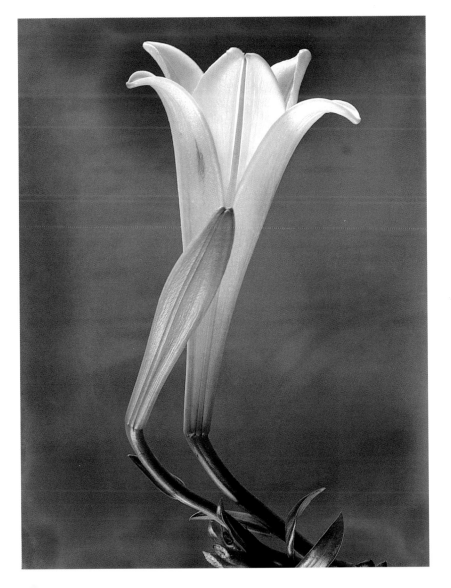

Doors, Mexico City, c.1925. This image was made in the last of the homes owned by Modotti and Weston in Mexico City. Nicknamed by them the 'Boat House', because the upper-storey studio room was a triangle coming to a sharp point, the house attracted them because of its airy, sunlit rooms. Modotti made several photographs of the geometric architectural elements of the house.

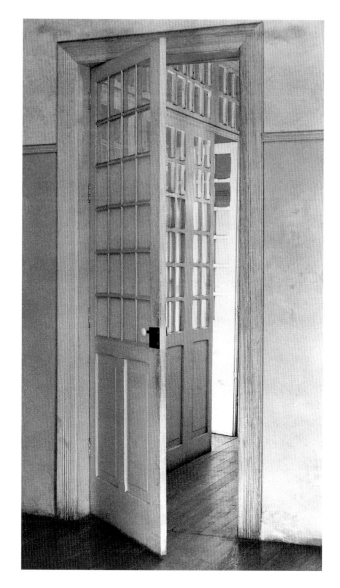

Labour Parade, Mexico City, 1926. *Labour Parade* is a straight documentary image, utilizing Modotti's customary attention to form, shot from the rooftop abode of painter Paul O'Higgins in downtown Mexico City. This photograph and the one that follows (page 45) reflect the artist's uncertainty about which direction her photography should take; both epitomize her struggle to meld the two major themes in her life – art and politics. These two pictures are the first to illustrate a combination of the formalist aestheticism of her earlier work with her growing interest and involvement in Mexican revolutionary politics.

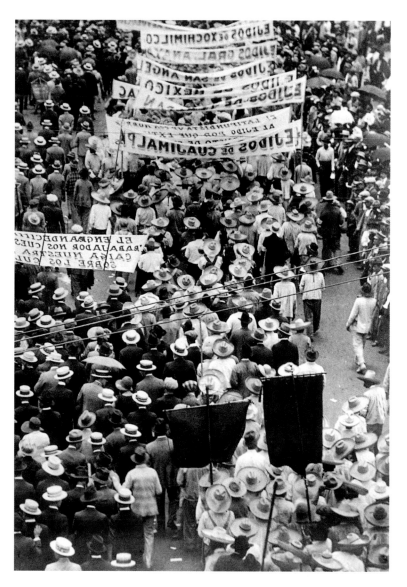

Workers' Parade, Mexico City, 1926. *Workers' Parade* is a cropped and enlarged detail, largely abstract. It is the aestheticism of this image, with its sunburst-like patterns of light on the hats, that stays in the memory, not its political content. The documentary image *Labour Parade* (page 43) was recently discovered in the archive of the prestigious arts magazine *Mexican Folkways*. This cropped image – also published in *Mexican Folkways* in 1926 shortly after it was made – was obviously the one Modotti preferred since it was this version she chose to exhibit.

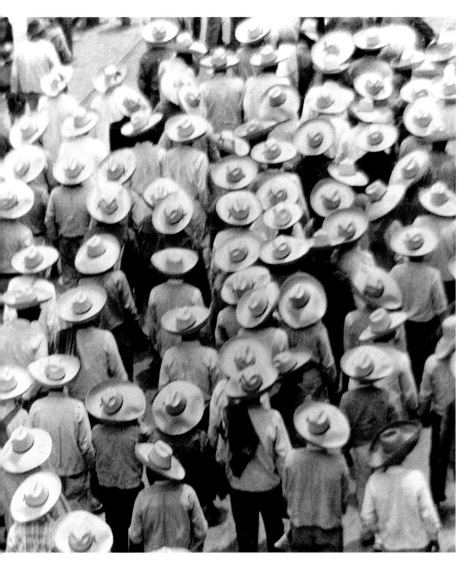

Woman with *Olla*, 1926. When the Mexican muralist Diego Rivera said o
Modotti's photography, 'It flowers perfectly in Mexico and harmonizes exactl
with our passion', he could have been referring to this image. The disparate
elements of this photograph combine to create a harmonious image charged
with political content. It is dominated by the lyrical sphere of the *olla* or wate
jar, and the tension of the triangular shape made by the woman's arm as she
steadies the heavy object on her shoulder. The aestheticism of these forms
coupled with the glossy, luminous quality of the *olla*, is what we first see whe
we look at the image. However, the photograph is also highly charged with sym-
bols of oppression. That water must be carried in such a way rather than pipe
into homes indicates a lack of development. The image also speaks of the labou
and burden of such tasks, which lie heavy on the shoulders of the poorest and
most disenfranchised of Mexicans.

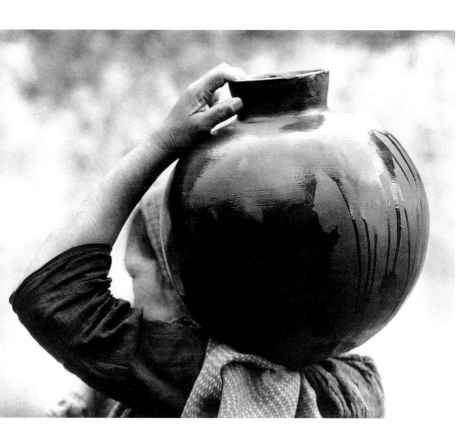

Crumpled Tinfoil, c.1926. A dramatic study in texture and contrast, this is one o
Modotti's rarest images: only one original print is known to exist. It is probabl
the most abstract of her photographs and was made during her most experi-
mental period. She produced her most diverse and innovative body of work from
1924 until 1927, the year she joined the Mexican Communist Party.

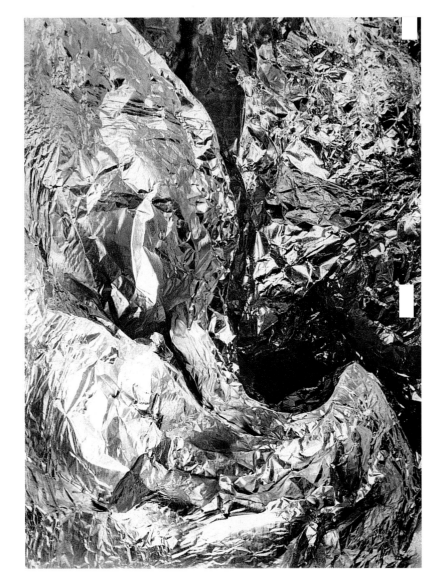

Indigenous Mask, c.1926. To photograph this *diablo* mask from the state of Guerrero, Modotti placed it on a traditional Mexican woollen *sarape*, whose horizontal stripes add a dynamic element to what would otherwise be a some-what static documentary image. In 1926 Modotti, and to a greater extent Weston, undertook a project to document the religious and folk art of Mexico for a book called *Idols Behind Altars* by the American writer Anita Brenner. It was a gruelling undertaking and the couple travelled thousands of miles across Mexico on a very tight budget to record hundreds of these artefacts.

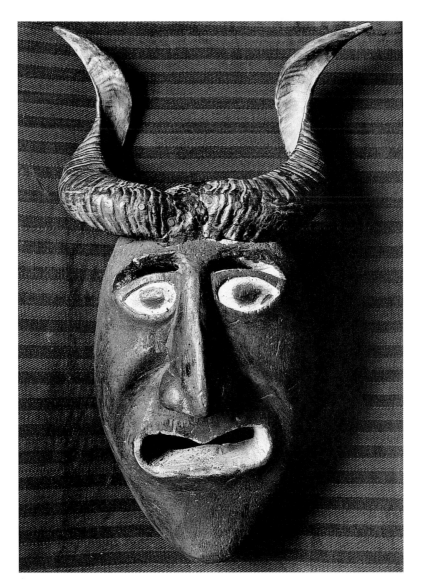

Hammock, c.1926. This strongly geometric image of a traditional Mexican hammock was probably also made for the *Idols Behind Altars* project. While many of the photographs of Mexican folk art taken by Modotti and Weston for Brenner's book have a rather static quality, perhaps as a result of their effort to record the object faithfully, this image appears quite starkly abstract. However, the tension created by the crisscrossing of its strings playfully implies that this is a hammock in use, weighted down by an invisible body.

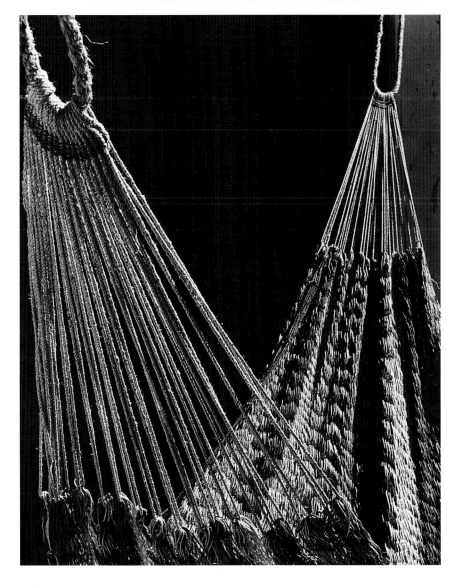

Tina Modotti from a Rivera Mural, Chapingo University, c.1926. Modotti posed for many of Rivera's murals, almost all of them covering the walls of the chapel at Chapingo University. Modotti had a brief affair with Rivera, whose politics and vast paintings had a profound effect on both her life and her photography. This detail is from the *Virgin Earth* mural, and its dramatic composition is infused with Modotti's sensuality.

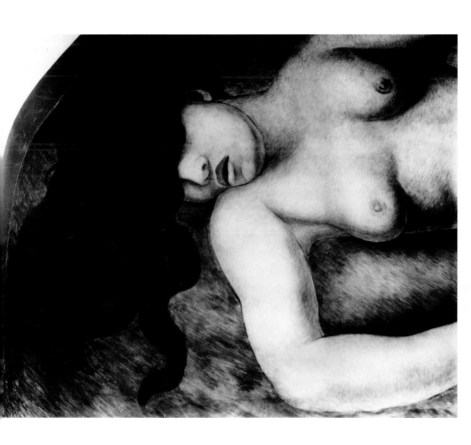

Tank No. 1, 1927. This is another image very much in accord with the ideas of the *Estridentistas* and their emphasis on the urban, the modern and the industrial. Modotti, however, has also imbued her photograph both with ideological content and with humanity. The ladder, the worker on the tank and the number '1' can be read as stressing the importance of industry in the development of the new post-revolutionary Mexico. In this case the emphasis is on oil and its potential for providing the Mexican worker with a means of climbing the ladder of success out of poverty and degradation.

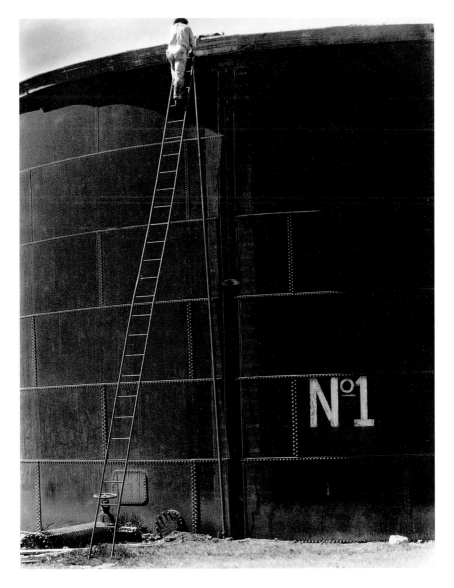

Construction Worker on Girders, 1927. The geometrical character of this composition, with its strong industrial component, is in keeping with the focus of List Arzubide's book of *Estridentista* poetry. Their leading member once described the group's aesthetic as being 'a theory of images ... controlled by means of spatial geometry'. One of his books was titled *Andamios Interiores* (*Interior Scaffolding*). Once again Modotti incorporates a worker in the image, even though, as in the previous photographs in this series, he is somewhat dwarfed by his working environment.

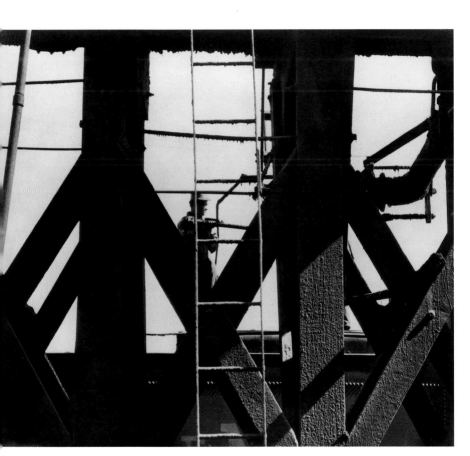

Hands Resting on Tool, 1927. Hands were a popular subject for art photogra-
phers in the 1920s and many made wonderful studies of them. Among the mos
outstanding were those by Imogen Cunningham and Man Ray. Modotti's approach
was unique, however, in that she often photographed hands with the tools of the
sitter's trade, as in this image, thus producing what were, in effect, 'portraits
of her subjects. In this photograph, Modotti's composition forces the viewer to
focus on grimed hands that represent hard work but paradoxically are portrayed
at rest, in a brief moment of respite before returning once more to the daily
grinding toil.

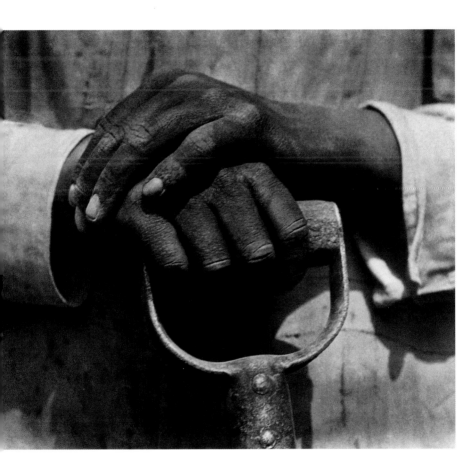

Mexican Boy in Sombrero, Veracruz, 1927. In December 1927 Modotti made a trip to the state of Veracruz to take photographs for a *Mexican Folkways* article by the editor Frances Toor on the 4th Congress of the League of Communities in the city of Jalapa. Modotti was often the only woman present among the hundreds of delegates who debated agrarian matters such as land distribution and the rights of local farmers (*agraristas*). During the trip she took this photograph of a young Mexican boy with his large Veracruz-style sombrero, dubbing him 'a proud little *agrarista* or son of one'. Modotti made many straight documentary photographs during her voyage but this image is not one of them. Although replete with political content, it still reflects her strong concern with form.

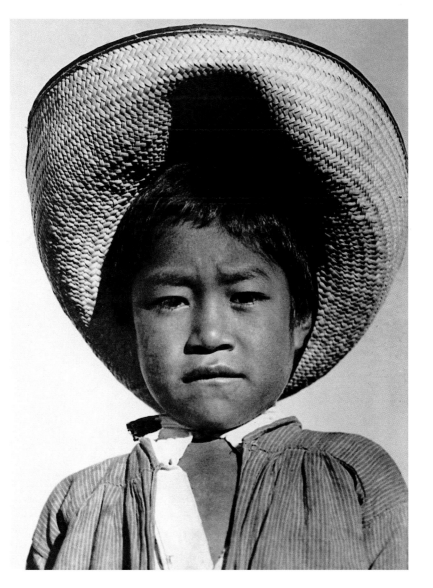

Baby Nursing, 1927. This is a photograph of Luz Jimenez and her baby Conchita Jimenez, who was of Aztec descent, was the model for 'Tradición' in Rivera's mural *Creation* and posed for many other artists at the time, including Weston She worked as a servant for Mona and Rafael Salas, both close friends o Modotti, and lived in a mountain village on the outskirts of Mexico City. With this harmonious composition Modotti seeks to portray the tender bond between mother and child. The image of health and contentment conveyed by the plump suckling youngster conveys the assertion that mother's milk is the best food for a baby. At the time, Indian women in Mexico were being encouraged to breast-feed their babies. The viewer is aware that the child is indigenous because o her earrings, which are of a traditional Aztec design.

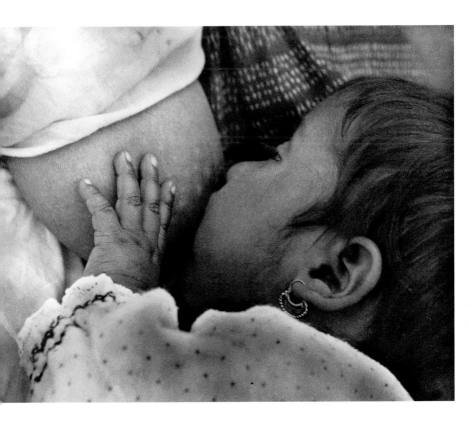

Loading Bananas, Veracruz, 1927. After the agrarian conference in Jalapa Modotti headed down to the steamy, tropical port city of Veracruz where she photographed this stevedore loading bananas into the hold of a ship. It is most likely that this picture was destined for inclusion in the book *Song of Man*, a eulogy to workers and their daily tasks. Modotti was very enthusiastic about this *Estridentista* project and immediately offered to supply the photographs. While the book was never published, several images from the series were reproduced in the prestigious *Forma* art magazine in 1927.

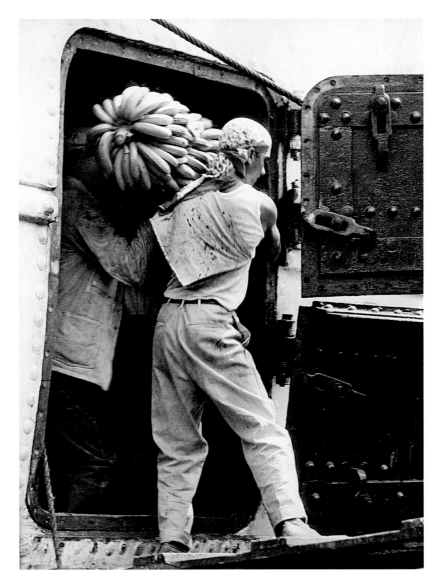

Bandolier, Ear of Corn, Guitar, 1927. Modotti joined the Mexican Communist Party in 1927 and during that year made several photographs that reflect the interest and allure of Communism. This image, however, is more representative of her fascination with the Mexican Revolution, and to make it she assembled together its emblems: the ear of corn that symbolized the struggle for land, the bandolier worn by the soldiers of the rebel armies, and the guitar echoing the music played around a thousand rebel camp fires. It was used as an illustration in a book of Mexican revolutionary song lyrics called *Canciones Revolucionarias*. The composition is bold and harmonious, the unity of the elements an uncompromising statement.

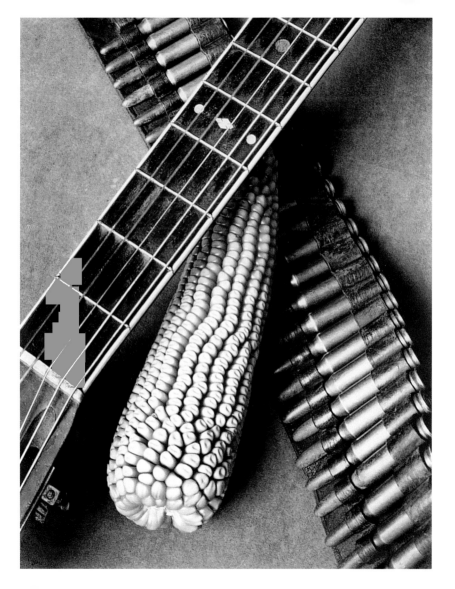

Lola Cueto, 1927. The accomplished Mexican painter and designer Lola Cueto was a close friend of Modotti. Cueto and her husband, the sculptor German Cueto, were prominent members of a group of bohemian artists that congregated in a Mexico City neighbourhood, home to many of the most esteemed Mexican artists of the time. Modotti and Weston were members of the same circle and played a prominent role in the weekly meetings for hot chocolate and discussion of ideas on art and revolution.

Hammer and Sickle, 1927. This is another simple but powerful image of assembled icons, this time containing no Mexican elements. It shows the symbols of international socialism and appropriately was hung on the walls of the Soviet Embassy in Mexico. It is clearly visible in a photograph Modotti made of a reception there, and also appears on the walls of her own apartment in a photograph taken by a local journalist when the police were searching it following Julio Antonio Mella's assassination.

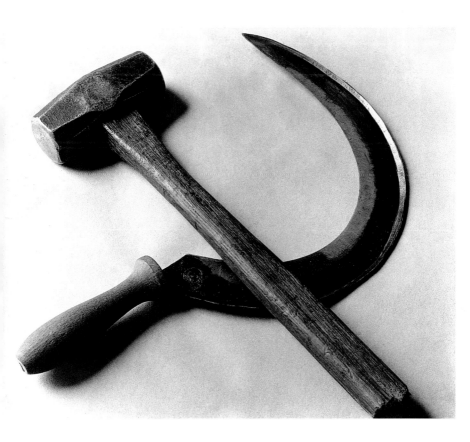

Mexican Hat with Hammer and Sickle, 1927. This is another emblematic image made in the year that Modotti joined the Mexican Communist party. The *mise-en-scène* melds the icons of both the Mexican and Russian revolutions. The ideologies of both were at the core of her political activism and speak volumes as to the direction her life and art would take. Many of these 'icons of the revolution' were published in *El Machete* newspaper and other Communist Party publications.

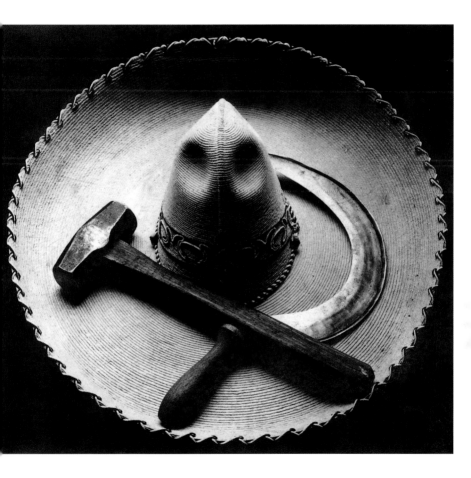

Labour 1 or Hands Washing, c.1927. As the title indicates, this photograph and *Hands Resting on Tool* (page 61) are part of a series that Modotti made on labour in Mexico. The focus is less on the hands than on the task being performed. The woman here is washing clothes on stones, a practice as ancient as Mexico City itself. Modotti's title makes the point that the labour of women, which often goes unrecognized and unpaid, is real work too. Modotti could also have been making a statement on class, since so many poor and indigenous women laundered the clothes of wealthier families as well as their own.

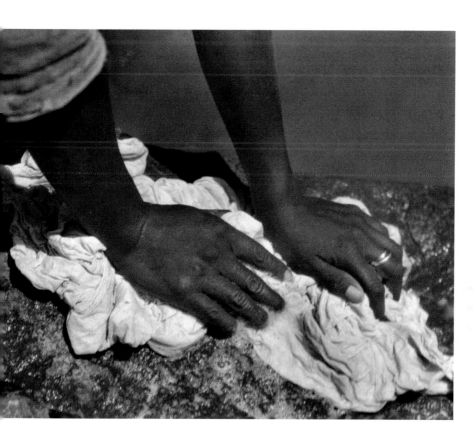

Stadium, Mexico City, c.1927. This sculptural study is one of Modotti's strongest abstract images. The composition pulls the viewer directly into the photograph with its alternating tones of light and shadows. Modotti, it appears, aimed to portray the scale of the enormous stadium and did so successfully through the strong lines and shadows of the seating that traverse the image, gradually moving our gaze to the left of the image and into infinity. The public that normally fill the benches are absent, irrelevant in the photographer's aim to transform the mundane into the majestic. This image illustrates well the formalist concern that preoccupied the great modernist master photographers of the era such as Charles Sheeler and Edward Weston.

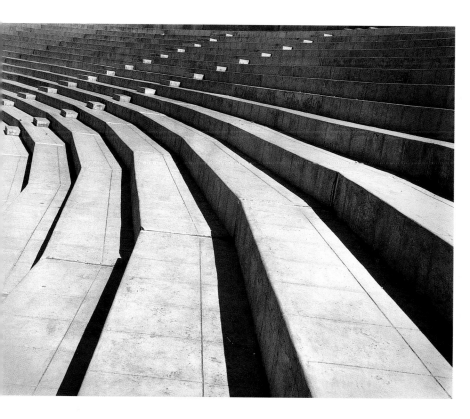

Mella's Typewriter, 1928. Its strong aestheticism combined with multiple layers of meaning makes this one of Modotti's most important photographs. On one level, it is a psychological portrait of her lover Julio Antonio Mella. This revolutionary Cuban fighter for social justice, a prolific writer, considered his typewriter a symbolic weapon, integral to the fight for liberation. The image is traversed by three diagonal bands, all of which relate to the power of words and the mechanics of their reproduction. The end result, at the top of the page, is a quotation from the writings of Leon Trotsky on the synthesis between art and revolution. Moreover, as the photograph itself is a means of reproduction, this image can be read as Modotti's own powerful pronouncement on the marriage of art and politics.

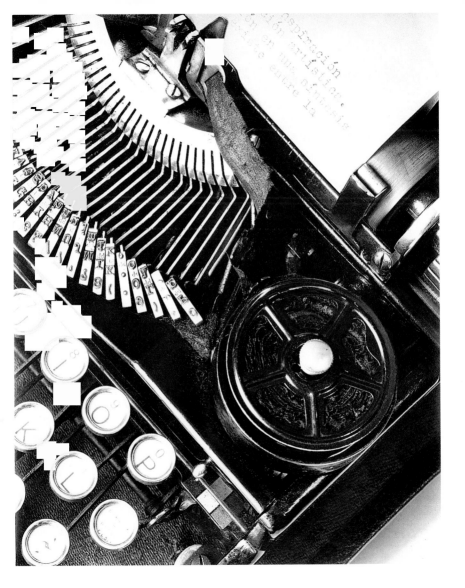

Communist Youth Association, 1928. This photograph was published in the *El Machete* newspaper in April 1928. Modotti probably made it for that purpose or for publication in other Communist publications. But it is no mere press photo: the composition is formal, intended to lend dignity and stalwartness to her subjects. These young Communists were frequent visitors to Modotti's home when she was living with Julio Antonio Mella, whom they regarded with awe and respect for his heroism in fighting a repressive Cuban government. Many of them were later imprisoned and persecuted in a crackdown on Communist militants.

Woman with Flag, Mexico City, 1928. This iconic image is one of Modotti's few set-up photographs. It was made on a rooftop terrace in Mexico City, and for many years the model was identified as the Mexican Communist fighter for social justice Benita Galeana. Galeana herself denied this and the model still remains unidentified. Modotti went to great lengths to create the props that dominate the photograph. A piece of what appears to be silk (it is unclear if it was red or black) was attached to a bamboo pole to create the makeshift flag that dominates the frame as it furls behind the 'striding' figure. The dignity of the model is accentuated by her attire: a traditional 'skirt' has been created from Indian cotton and is held up by a woven sash, both typically worn by poor indigenous women. The woman, however, is not Indian but a *mestiza*, of mixed blood, and her highly polished 'city' shoes and silk stockings belie her created identity.

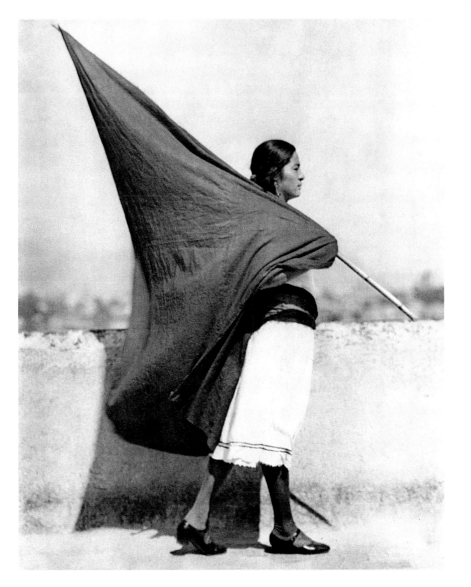

Railway Worker's Daughter, Mexico City, 1928. This is one of a series of photographs made by Modotti on an assignment for *El Machete*, published in the newspaper in June 1928. Mella was then working at the paper and apparently suggested that Modotti do a series of contrast photos on the disparities in Mexican society. They ran on the front page and juxtaposed children from affluent areas of Mexico City, such as the Paseo de Reforma, with those from poor districts such as the Colonia de la Bolsa. This little girl is the daughter of a railway worker from this area, where Modotti made many of her most poignant images of poverty. The painter Paul O'Higgins, who knew her well at the time, described how she photographed in these districts: 'She would go to the people, talk with them but not try to immediately take a photograph ... that is the reason her photography has a certain rooted character, of going to the essence of the thing.'

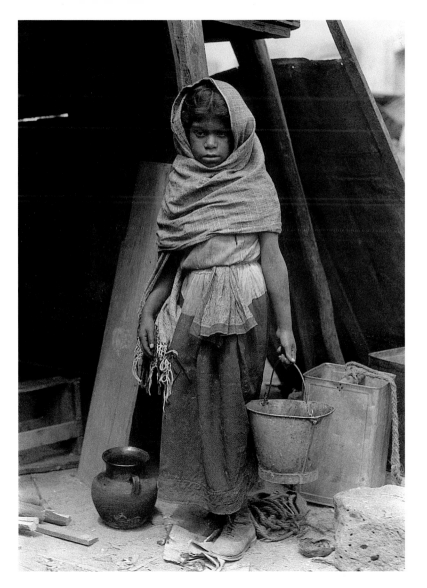

Julio Antonio Mella, 1928. Modotti's romantic portrait of the Cuban revolutionary Julio Antonio Mella is her most widely disseminated image. Mella was revered by radicals throughout Latin America for his courage as a student leader in Havana in the 1920s: he was imprisoned for protesting against the government of the dictator Machado and went on a lengthy hunger strike before being expelled to Mexico. He was assassinated as he walked home arm in arm with Modotti in January 1929. As news of his murder was broadcast in articles throughout the Americas, it was this photograph that accompanied them. It so completely represented a continent's vision of Mella as the heroic revolutionary that it was soon reproduced on buttons and posters, plaques were made in its likeness and busts were sculpted from it.

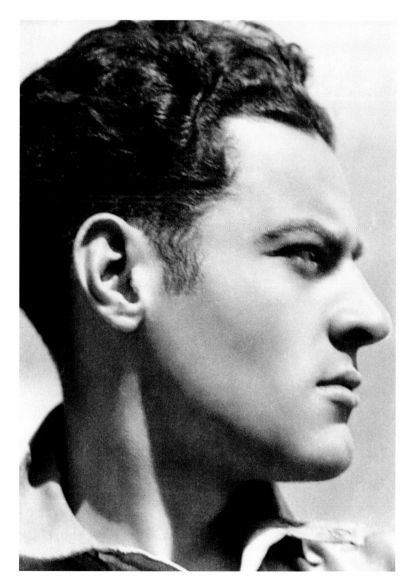

Mexican Peasants Reading *El Machete*, 1928. *El Machete* newspaper wa[s]
founded by Diego Rivera and some of his fellow artists. Until about 1926 it was
radical, innovative broadsheet that reproduced enormous red, white and blac[k]
woodcuts by the muralist painters, among them David Alfaro Siqueiros an[d]
Rivera himself. By 1928 it had become the organ of the Mexican Communist Part[y]
and basically reflected the party line, though it still contained some innovativ[e]
artwork. Modotti posed these *campesinos* for this photograph. The image i[s]
shot from above and we are unable to see the faces of the subjects. Instead, th[e]
photographer has focused on the iconic sombreros, symbolic of Mexico's poo[r]
peasant farmers. The front page of *El Machete* displays the slogan 'All the Lan[d]
not just Pieces of Land!'; the struggle for land was a fundamental concern of th[e]
Mexican Revolution. This is a trademark Modotti image in which the artist ha[s]
infused an almost abstract image with a political charge; has taken simple for[m]
and given it content.

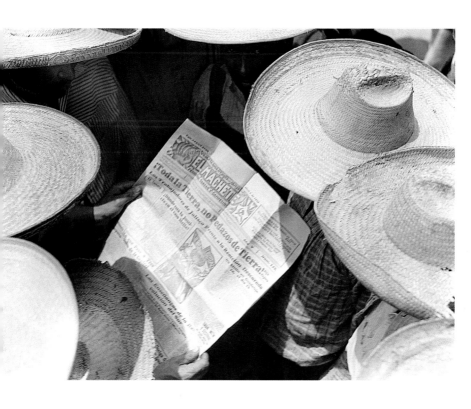

Hands of the Puppeteer, 1929. The arrangement of elements in this photograph produces a stunning combination of strength and sensitivity. The tension created by the strings of the puppet, the sensitivity in the hands of the puppeteer coupled with the strength of his arms, and the shadows falling on the wall behind, combine to make this one of Modotti's strongest images.

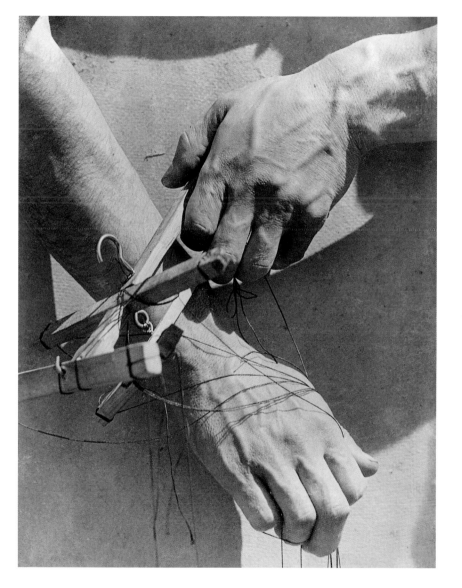

Woman Carrying *yecapixtle* Gourd, Tehuantepec, 1929. Modotti made a photo-graphic trip to the isthmus of Tehuantepec, located in the hot, tropical lowland of Oaxaca, in 1929. She visited the towns of Juchitan and Tehuantepec itself where there still remained the vestiges of a matriarchal enclave. Modotti photographed these latter-day fertility goddesses – known as *Tehuanas* – with their plump naked children grafted to their bodies, bathing in the river and walking to market with painted *yecapixtle* gourds on their heads. While most of Modotti's photographs of *Tehuanas* are simple, unmanipulated images of them going about their daily lives, she also made a few carefully composed emblematic portraits, of which this image is a fine example.

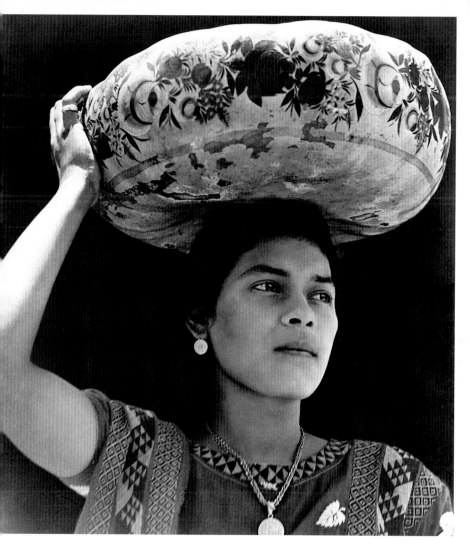

Tehuana, **Tehuantepec, 1929.** In February 1929, the prestigious art magazine *Creative Art* published a review of Tina Modotti's photography. The article quotes her as saying that she had recently come to consider her ideal photograph to be the 'perfect snapshot', adding that 'the moving quality of life rather than still studies absorbs her.' To create the body of work she produced in Tehuantepec, Modotti had to work quickly and often on impulse. In a letter to Edward Weston at the time, she explained how 'all the exposures had to be done in such a hurry: as soon as they saw me with the camera the women would automatically increase their speed of walking, and they walk swiftly by nature.' With its sense of movement, this impromptu shot of a *Tehuana* in a traditional multicoloured sweeping skirt embodies Modotti's new focus.

Woman in a Headscarf, Tehuantepec, 1929. This recently discovered, rather severe portrait of an unsmiling woman is the exception to the dozens of others Tina Modotti made of women in the Tehuantepec region. In this mysterious photograph the melancholic sitter looks straight into the camera, her head covered by a dark *rebozo* (a type of shawl) — an indication that perhaps she was in mourning. If that was the case, it may be a clue as to why the photographer made this portrait: Modotti herself was in mourning on her visit to Tehuantepec, undertaken only a few months after her companion Julio Antonio Mella was murdered at her side in Mexico City.

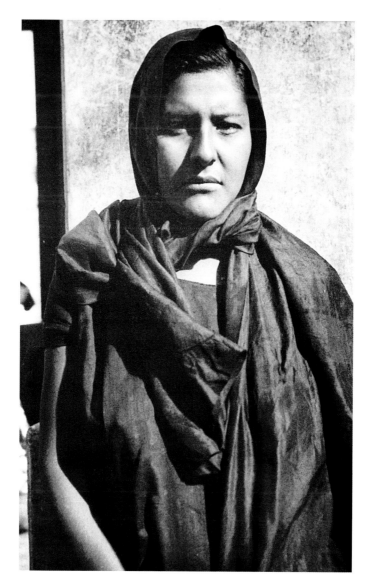

Young Woman Carrying a Gourd, Tehuantepec, 1929. This charming portrait of a young *Tehuana* illustrates well the empathy Tina Modotti felt for these proud women who enchanted her to such a degree that they and their children were her only subjects during her visit to their homeland. Many of Mexico's artists and writers admired the *Tehuanas*, and used images of them in their work as representations of an authentic, uncowed pre-hispanic culture. Several of these intellectuals also adopted their traditional Zapotec clothing, most notable among them the Mexican painter Frida Kahlo.

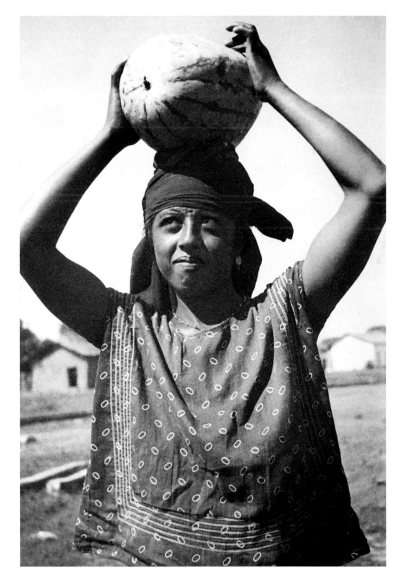

Mexican Mother and Baby, 1929. Modotti, who was unable to have children because of a uterine problem, made many photographs of women and their off-spring. She appears to have been fascinated by the bond between them, which she often expressed by focusing on the relationship between their bodies. In this image of a woman from Oaxaca and her child, it is the soft, sinuous forms of mother and baby that interest her rather than the faces of her subjects.

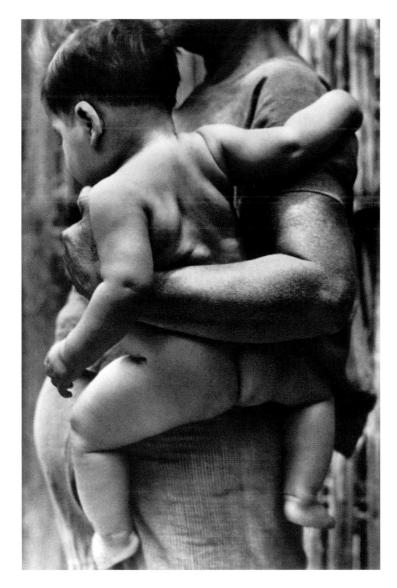

Ione Robinson, 1929. Ione Robinson, nineteen years old when this shot was taken, had gone to Mexico on a Guggenheim fellowship in the summer of 1929. She worked as an assistant to Rivera on the National Palace murals and had a brief affair with him. While she was in Mexico she stayed with Modotti, who made several portraits of her. This image is the most compelling and innovative of them and shows how Modotti experimented in her portraiture, often using unusual angles and strong graphic elements.

Baltasar Dromundo, 1929. This dramatic portrait illustrates Modotti's uncon-
ventional approach to portrait photography. There is a sense of intimacy in this
picture; of secrecy and a subtle sensuality. In 1929 Baltasar Dromundo was a
serious, intense student leader and close friend of Modotti's lover Julio Antonio
Mella. After Mella's assassination he became closer to Modotti and fell in love
with her. Though Modotti did not reciprocate his feelings, she was very fond of
the young radical. Dromundo became the driving force behind her first one-
person show in December 1929 by securing the venue and obtaining the funds
to underwrite it.

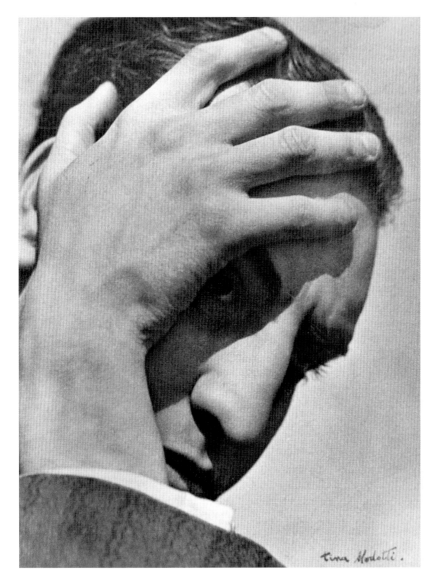

Louis Bunin, Puppeteer, 1929. The young Chicago artist Louis Bunin came t
Mexico to work with Rivera on his murals. While there he became intereste
in marionette theatre, which he considered most appropriate in a country wher
illiteracy and the prevalence of handicrafts make the population sympatheti
to dramas with puppets. Modotti agreed and made many photographs of hir
and his marionette theatre, becoming very fond of him in a slightly materna
fashion. In this tender, harmonious portrait, Bunin is framed by the props of hi
trade, his downcast gaze making the puppet he holds in his hands the focal poin
of the image.

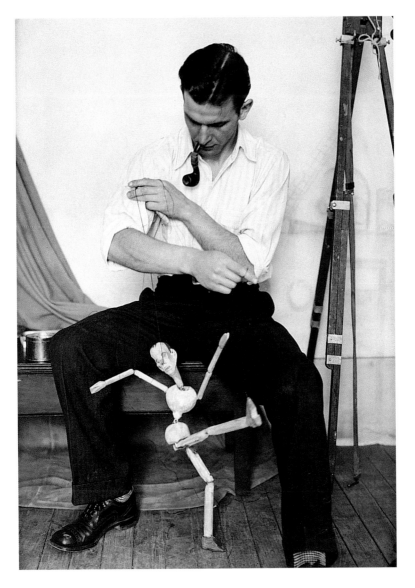

René D'Harnoncourt Puppet, 1929. Modotti made this 'portrait' of René D'Harnoncourt at a marionette performance organized and performed by the puppeteer Louis Bunin for the wife of the US ambassador in Mexico. D'Harnoncourt, who later became Director of the Museum of Modern Art in New York, is depicted in his typically elegant attire in the antique store and gallery of his employer, the American art dealer Frederick Davis.

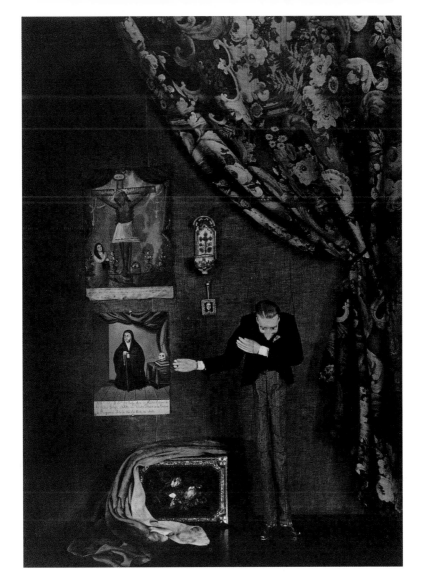

Hairy Ape **Puppets, 1929.** While many of Modotti's marionette photographs carry strong social messages about capitalism and police brutality, there is a lightness in some of these images not present in most of the others she made during 1929. Eugene O'Neill's play *The Hairy Ape* (1922) was hard-hitting and anti-establishment. When Louis Bunin approached the wife of the US ambassador for money to fund his marionette theatre she agreed, but on condition that the artist abandon his plans to produce *The Hairy Ape*. He refused, but it appears that a compromise was reached and she funded a show at the Embassy Ball that did not include this work. It was, however, eventually performed by Bunin and his wife at the Casa del Indio in an impoverished area of Mexico City, and later in New York.

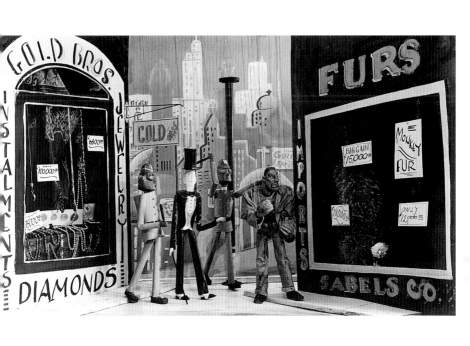

Antonieta Rivas Mercado, 1929. This portrait of the Mexican writer and wealthy arts patron Antonieta Rivas Mercado was taken during a professional sitting. Rivas Mercado had commissioned Modotti to photograph herself and her sisters. The intention was to give Modotti paid work at a time when her commissions to photograph Mexico's upper class had fallen off as a result of attacks in the Mexican press. Unfortunately, Rivas Mercado's own life fell into disarray in 1929 and Modotti did not secure payment for all of the photographs. In 1931 Rivas Mercado killed herself in Paris near the altar of Notre-Dame cathedral. She was a leading member of the *Contemporáneos* group of artists and writers whose members were not leftists like most of the artists with whom Modotti fraternized. Nevertheless Modotti's photographs were reproduced in their prestigious literary magazine of the same name, and she was their photographer of choice when it came to documenting their work.

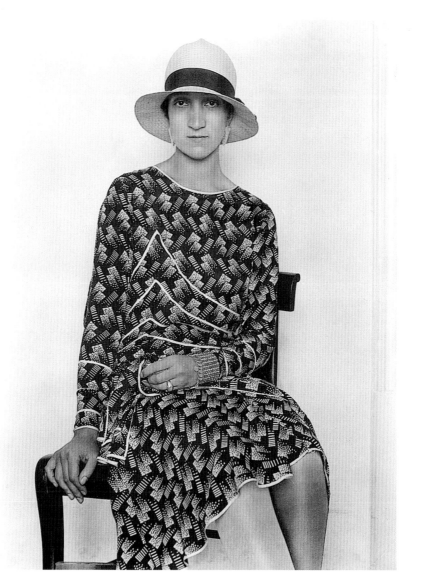

Diego Rivera Mural with Antonieta Rivas Mercado, Mexico City, c.1929. In this detail from a Rivera mural in the Secretariat of Education in downtown Mexico City, the artist has depicted Antonieta Rivas Mercado being handed a broom by a revolutionary indigenous woman with a rifle on her back and a bandolier of bullets across her chest. Rivas Mercado is shown wearing a modern dress with elegant shoes and expensive jewellery, including a large diamond ring on her finger. 'If you want to eat you have to work' is written in Spanish in the banner above this scene. Although even today in Mexico it is overwhelmingly Indian women who work as the servants of the middle and upper classes, and women such as Rivas Mercado rarely pick up a broom, Rivera chose to make his point using Rivas Mercado, who did not share his ideology, rather than any of the well-off leftist women he knew who also employed Indian women to do their menial tasks.

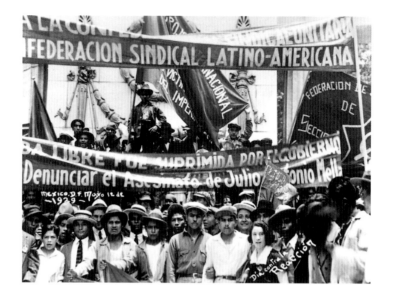

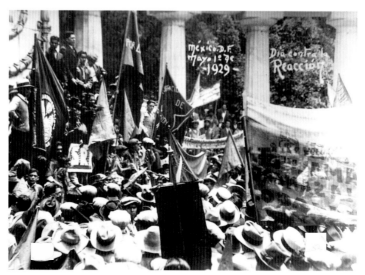

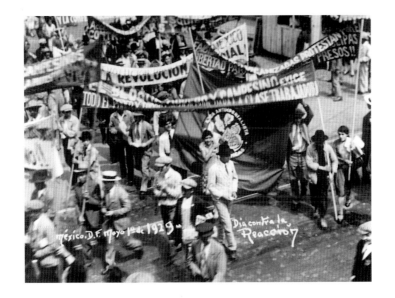

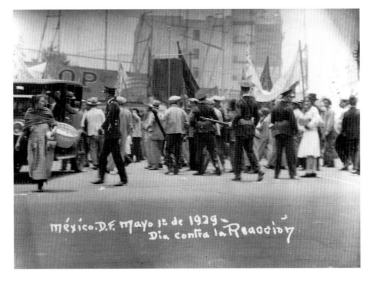

(previous page) Day Against Reaction, Mexico City, 1929. This demonstration, organized in May 1929, protested against a recent crackdown on Mexican Communists. Modotti was on assignment for *El Machete* newspaper to document this May Day march, which later turned violent and led to the imprisonment of yet more Mexican leftists. These four photographs, out of a total of eighteen, follow the march from its convivial beginnings: artists and workers pose arm in arm for the camera; in the second image fiery orators address a still-relaxed crowd; the march winds its way through downtown Mexico City to a rowdy protest rally at the United States embassy; and finally, in the last image Modotti made of this protest, the police break up the crowd with sticks. Several people were injured in the resulting fray and Modotti had to leave the scene for her own safety and to avoid arrest.

Palm Trees, Tehuantepec, c.1929. In this image of swaying palm-tree fronds Modotti speaks to us of the indolence of the tropics, of the sensual warm breezes and the swish of the skirts worn by the women of the Isthmus of Tehuantepec. It is interesting to compare this photograph with those of palm trees made by Weston while he was in Mexico. His are ramrod straight, their soaring monumental trunks penetrating the sky.

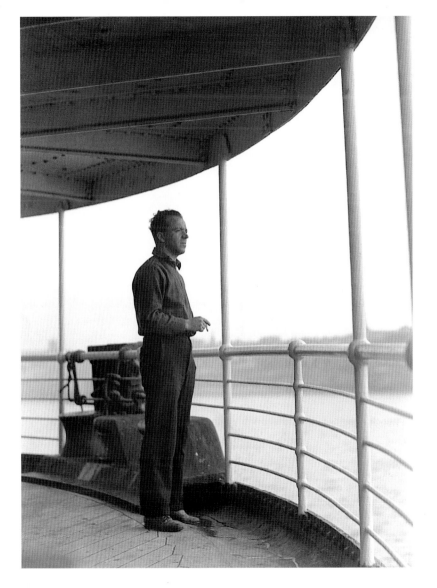

Once Again, 1930. It is interesting to compare this photograph of a mother and child taken while Modotti was in Germany with those she made of mothers and their children in Mexico. In Mexico the works were mostly an affirmation of motherhood. While this image also emphasizes the mother–child bond in the entwining curves of the mother's arm and belly and the child's leg, the title suggests a more critical position; the image is a comment on the necessity for women to limit the number of children they bear. A companion image shows the same mother with another child, a toddler, hanging on to her dress.

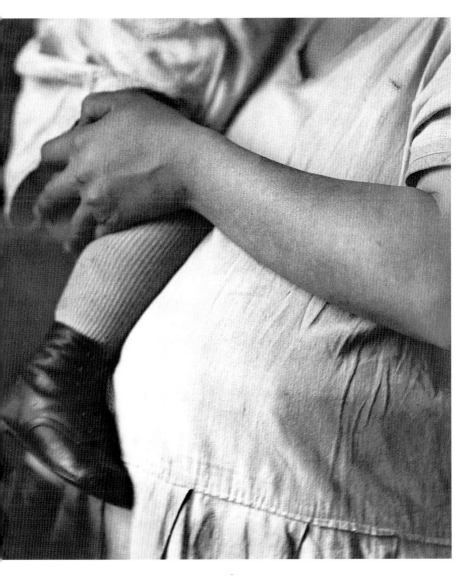

1896 Born on 17 August in Udine, Italy, the third child of Assunta an
Giuseppe Modotti.

1898 Her father moves the family to Klagenfurt, Austria, in search of work

1905 They return to Udine, where the family's financial circumstance
begin to deteriorate.

1906 Her father decides to leave Italy for America, hoping to earn enoug
money to send for his wife and children at a later date.

1908 Tina is forced to work in a local silk factory to help support th
family.

1913 Emigrates to America to join her father and sister. Works as a mode
for a local department store in San Francisco.

1915–1917 Visits the Pan-Pacific Exposition and meets the poet-painter Roubai
de l'Abrie Richey, known as 'Robo'. Works as an actress in a loca
Italian theatre.

1918 Moves with Robo to Los Angeles so that she can pursue a Hollywoo
film career.

1920 Acts in silent films; plays leading role in *The Tiger's Coat* (1920).

1921 Models for Edward Weston and begins an affair with him.

1922 Travels to Mexico to join Robo, but he dies just two days after he
arrival. Suffers a double bereavement when her father dies aroun
the same time in California.

1923 Moves to Mexico with Weston. Manages his studio in return for pho
tography lessons. Begins photographing with a Korona camera.

1924 First exhibition of her work; she wins the runner-up prize. Begins he
collaboration with *Mexican Folkways* magazine.

1925 Starts documenting murals by Diego Rivera. Temporarily takes ove
Weston's studio work and shows alongside him in a joint exhibition.

1926 Takes part, with Weston, in a huge project to provide photographs fo

Anita Brenner's book *Idols Behind Altars*. Becomes involved in a projected film on the history of the Mexican Revolution, which would make use of her photographs of murals. Her affair with Weston ends and he leaves Mexico to return to his family in California.

1927 Begins using a Graflex camera. Wins an award in a collective exhibition. Joins the Mexican Communist Party.

1928 Lives with Cuban rebel Julio Antonio Mella. Embarks on photojournalism project for the Communist Party newspaper, *El Machete*. Shares first prize in a collective show.

1929 Mella is gunned down in the street while walking by her side. Ensuing murder trial accuses her of the crime and attacks her morality. Visits the Tehuantepec region to take photographs of its women. Holds her first solo exhibition.

1930 Framed for an assassination attempt on the Mexican president, she is arrested and expelled from the country. Travels to Berlin. Feels unable to take photographs there. Moves on to Moscow. Joins the Soviet Communist Party and becomes immersed in political work.

1931 Gives up photography almost completely. Works full-time for the Comintern, the international Communist organization.

1932–1933 Carries out undercover missions to political prisoners and their families.

1935–1939 Participates in Spanish Civil War, working for International Red Aid and writing articles for its newspaper, *Ayuda*.

1939 After Franco's victory returns to Mexico and lives incognito.

1942 Dies alone, and in suspicious circumstances, in a Mexico City taxi cab in the early hours of 6 January.

Photography is the visual medium of the modern world. As a means of recording, and as an art form in its own right, it pervades our lives and shapes our perceptions.

55 is a new series of beautifully produced, pocket-sized books that acknowledge and celebrate all styles and all aspects of photography.

Just as Penguin books found a new market for fiction in the 1930s, so, at the start of a new century, Phaidon **55**s, accessible to everyone, will reach a new, visually aware contemporary audience. Each volume of 128 pages focuses on the life's work of an individual master and contains an informative introduction and 55 key works accompanied by extended captions.

As part of an ongoing program, each **55** offers a story of modern life.

Tina Modotti (1896–1942) was a pioneer among the few women photographers of the 1920s. Having studied with Edward Weston, she soon became an outstanding photographer in her own right. Linked to some of the most important artistic and political developments of the twentieth century, she was a significant influence on future Mexican photographers, including Manuel Alvarez Bravo and Graciela Iturbide.

Margaret Hooks writes on fine art photography for numerous journals, including *ARTnews* and *Afterimage*. Her most recent publication is the award-winning biography *Tina Modotti: Radical Photographer* (2000).

Phaidon Press Limited
Regent's Wharf
All Saints Street
London N1 9PA

Phaidon Press Inc.
180 Varick Street
New York NY 10014

www.phaidon.com

First published 2002
©2002 Phaidon Press Limited
ISBN 0 7148 4156 0

Designed by Julia Hasting
Printed in Hong Kong

A CIP record of this book is available from the British Library. All rights reserved. No part of this publication may

Thanks to: Throckmorton Fine Art, NY; Museum of Modern Art, NY; Fototeca del INAH, Mexico; J. Paul Getty Museum; Museo de Arte Moderno, Mexico City; National Gallery of Australia; Metropolitan Museum of Art, NY; The Detroit Institute of Art; The New Orleans Museum of Art; Center for Creative Photography, Arizona; Philadelphia Museum of Art; Baltimore Museum of Art; Minneapolis Museum of Art; Art Institute of Chicago.